# The Precious Promises of the Gospel

by
**Joseph Alleine**
(1634–1668)

Edited by Dr. Don Kistler

Soli Deo Gloria Publications
*. . . for instruction in righteousness . . .*

Soli Deo Gloria Publications
P. O. Box 451, Morgan PA 15064
(412) 221-1901/FAX 221-1902
www.SDGbooks.com

\*

*The Precious Promises of the Gospel* is taken from the Soli
Deo Gloria book *Heaven Opened,* by Richard Alleine.
This chapter is one of two penned by Joseph Alleine,
the author of *A Sure Guide to Heaven.* It is © 2000 by
Soli Deo Gloria. All rights reserved.
Printed in the USA.

\*

ISBN 1-57358-135-6

## The Precious Promises of the Gospel

O all you inhabitants of the world dwelling on the earth, come; see and hear; gather yourselves together unto the proclamation of the Great King. Hear, you who are afar off and you who are near! He who has an ear to hear, let him hear. I am the voice of one crying in the wilderness, "Prepare ye the way of the Lord. Let every valley be exalted, and every mountain be made low, for the glory of the Lord is to be revealed." Go through, go through the gates, prepare the way. Cast up, cast up the highway; gather out the stones, lift up the standard for the people; for the Lord proclaims salvation to the ends of the earth. Tidings! tidings, O you captives!

Hear, all you who look for salvation in Israel. Behold, I bring you glad tidings of great joy, which shall be unto all people. Blessed news! Prepare your ears and hearts! The Lord has commanded me, saying, "Go unto the people, and sanctify them; let them wash and be ready; for the Lord is coming down upon Mount Zion in the sight of all nations; not in earthquakes and fire, not in clouds and darkness, not in thunderings or burnings, rending the mountains and breaking the rocks in pieces." He speaks not to you out of blackness, darkness, and tempests. You shall say no more, "Let not God speak to us lest we die." He comes peaceably; the law of kindness is in His mouth. He preaches peace; peace to him who is afar off and to him who is near. Behold, how He comes, leaping upon the mountains. He has passed Mount Ebal (Deuteronomy 11:20; 27:12–13); no more wrath or cursing. He is come to Mount

Gerizim, where He stands to bless the people. As Mordecai to his nation, He writes "the words of truth and peace, seeking the welfare of His people, and speaking peace to all His seed."

Behold how He comes! Clothed with flames of love, with bowels of compassion, plenteous redemption, and multiplied pardons.

Hearken therefore, O you children, hearken to me. To you it is commanded, O people, nations, and languages, that at what time you hear the joyful sound, the trump of jubilee, the tidings of peace, in the voice of the everlasting gospel, you fall down before the throne, and worship Him who lives forever and ever.

Arise and come away; prepare, prepare yourselves. Do not hear with an uncircumcised ear; you are not looking upon a common thing. Behold, the throne is set, the throne of grace, where majesty and mercy dwell together. From there the Lord will meet you; from there He will commune with you; from the mercy seat, from between the cherubims, upon the ark of the testimony. Lo, the Lord comes out of His pavilion, the mighty God from Zion. His glory covers the heavens, the earth is full of His praise. A fire of love goes before Him; mercy and truth round about Him; righteousness and peace are the habitation of His throne. He rides on His horses and chariots of salvation; the covenant of life and peace is in His mouth.

Rejoice, you heavens; make a joyful noise to the Lord, all the earth. Let the sea roar, the floods clap their hands, and the multitudes of the isles rejoice. Stand forth, the host of heaven; prepare your harps, cast down your crowns, be ready with your trumps; bring forth your golden vials full of odors, for our voice will

jar, our strings will break, we cannot reach the note of our Maker's praise.

Yet, let those who dwell in the dust arise and sing. Bear your part in this glorious service, but consider and attend. Call out your souls, and all that is within you. Lift up your voices, fix your eyes, enlarge your hearts, extend all their powers. There is work for them all. Be intent and serious, you cannot strain too high.

Come forth, you graces, set the way; be all in readiness. Stand forth, faith and hope. Flame, O love! Come, you warm desires, and break with longing. Let fear, with all veneration, do its obeisance. Joy, prepare your songs; call up all the daughters of music to salute the Lord as He passes by. Let the generation of the saints appear and spread the way with boughs and garments of salvation, and songs of deliverance. You stand this day, all of you, before the Lord your God, your captains, your elders, your officers, with all the men of Israel, your little ones, your wives, and the stranger that is within your camp, from the hewer of wood to the drawer of water, that you should enter into covenant with the Lord your God (Deuteronomy 29:10–13), and into His oath, which the Lord your God makes with you unto Himself and, that He may be unto you a God, as He has said unto you, and as He has sworn.

I have done my errand. The messenger of the morning disappears when the Orient Sun comes forth out of His chambers. I vanish, I put my mount in the dust. The voice of the Lord! The soft and still voice! O my soul, wrap your face in the mantle, bow yourself to the ground, and put yourself into the cleft of the rock while Jehovah proclaims His name, and makes all His goodness to pass before you.

## *The Voice of the Lord*

Hear, O you ends of the earth; the mighty God, the Lord has spoken: Gather My saints unto Me, those who have made a covenant with Me by sacrifice (Psalm 50:1, 5). Behold, I establish My covenant between Me and you (Genesis 17:7). By My holiness have I sworn that I will be your covenant Friend. I lift up My hand to heaven. I swear I live forever, and because I live you shall live also (John 14:19). I will be yours (Jeremiah 32:38–40), yours for all intents and purposes, your refuge and your rest (Jeremiah 50:6; Psalm 90:1; Psalm 46:1), your patron and your portion (Psalm 73:26; Isaiah 25:4–5), your heritage and your hope, your God and your guide (Psalm 48:14). While I have, you shall never want; and what I am to Myself, I will be to you (Psalm 34:9–10). You shall be My people, a chosen generation, a kingdom of priests, a holy nation, a peculiar treasure unto Me above all people (Exodus 19:5–6; 1 Peter 2:9). I call heaven and earth to witness this day that I take you for Mine forever. My name shall be upon you, and you shall be pillars in the temple of your God, and shall go out no more (Revelation 3:12).

My livery shall you wear, and the stamp of My own face shall you carry (Ezekiel 36:25–26; Ephesians 4:24); and I will make you My witness and the epistles of Christ unto the world (2 Corinthians 3:3). You shall be chosen vessels to bear My name before the sons of men. And that you may see that I am in earnest with you, lo, I make with you an everlasting covenant, ordered in all things and sure (2 Samuel 23:5). And I do here solemnly deliver it to you as My act and deed, sealed with

sacred blood (1 Corinthians 11:25), and ratified with the oath of a God (Hebrews 6:17) who cannot lie, who knows no place for repentance (Titus 1:2).

Come, you blessed ones, receive the instrument of your salvation: take the writings, behold the seals; here are the conveyances of the kingdom. Fear not, the donation is full and free. See, it is written in blood, founded on the all-sufficient merits of your Surety (Hebrews 9), in whom I am well pleased (Matthew 3:17), whose death makes this testament unchangeable forever; so that your names can never be put out, nor your inheritance alienated, nor your legacies diminished. Nothing may be altered, nothing added, nothing subtracted, no, not forever (Galatians 3:15–17). Happy art thou, O Israel! Who is like unto thee, O people (Deuteronomy 33:29)! Only believe, and know your own blessedness. Attend, O My children, unto the blessings of your Father; hear and know the glorious immunities and the royal prerogatives that I here confirm upon you.

Here I seal to you your pardons. Though your sins are as many as the sands and as mighty as the mountains, I will drown them in the deeps of My bottomless mercies (Micah 7:19). I will be merciful to your unrighteousness. I will multiply your pardon (Hebrews 8:12; Isaiah 55:7); where your sins have abounded, My grace shall superabound; though they be as scarlet, they shall be white as snow; though red like crimson, they shall be as wool (Isaiah 1:18). Behold, I declare Myself satisfied and pronounce you absolved (Job 33:24). The price is paid, your debts are cleared, your bonds are canceled (Isaiah 43:25; Colossians 2:13–14).

Whatever the law, conscience, or the accuser has to

charge upon you, I here exonerate and discharge you. I even I, am He who blots out your transgressions for My name's sake. Who shall lay anything to your charge when I acquit you? Who shall impeach or implead you when I proclaim you guiltless (Romans 8:33–34)? Sons, daughters, be of good cheer; your sins are forgiven you (1 John 2:12; Mark 9:2). I will sprinkle your consciences, and put the voice of peace into your mouths (Ezekiel 36:25; Hebrews 9:14; Isaiah 57:19), and they shall be your registers in which I will record your pardon, and the voice of guilt, wrath, and terror shall cease (Hebrews 10:22; Isaiah 27:4–5).

Here I sign your release from the house of bondage (Romans 6:17–18; 1 Corinthians 7:22). Come forth, you captives; come forth, hope; for I have found a ransom (Job 33:24). I proclaim liberty to the captives, and the opening of the prison to those who are bound (Isaiah 61:1; 42:7). Behold, I have broken your bonds, shaken the foundations of your prisons, and opened the iron gates (Luke 4:18). By the blood of the covenant I have sent forth the prisoners out of the pit wherein there is no water (Zechariah 9:11). Arise, O redeemed of the Lord; put off the raiment of your captivities, arise and come away.

The dark and noisome prison of sin shall no longer detain you (John 8:34–36). I will loosen your fetters and knock off your bolts. Sin shall not have dominion over you (Romans 7:14). I will heal your backslidings, I will subdue your iniquities (Micah 7:19; Jeremiah 3:12), I will sanctify you wholly (1 Thessalonians 5:23–24), and will put My fear in your hearts so that you shall not depart from Me (Jeremiah 32:40). Though your corruptions are strong and many, yet the aids of My Spirit, the

cleansing virtue of My Word, and the medicine of My corrections shall so work together with your prayers and endeavors that they shall not finally prevail against you, but shall surely fall before you (Ezekiel 36:37; Ephesians 5:26; Isaiah 27:9). From the strong and stinking jail of the grave I deliver you. O death, I will be your plague. O grave, I will be your destruction (Hosea 13:14). My beloved shall not ever see corruption (Psalm 16:10). I will change your rottenness into glory, and make your dust arise and praise Me (Daniel 12:2–3; Isaiah 26:19). What is sown in weakness, I will raise in power; what is sown in corruption, I will raise in incorruption; what is sown a natural body, I will raise a spiritual body (1 Corinthians 15:42–44). This very flesh of yours, this corruptible flesh, shall put on incorruption; and this mortal flesh shall put on immortality (1 Corinthians 15:53). Death shall be swallowed up in victory and mortality of life (1 Corinthians 15:54; 2 Corinthians 5:4).

Fear not, O children. Come, and I will show you the enemy that you dreaded. See, here likes the king of terrors, like Sisera in the tent, fastened to the ground with a nail struck through his temples. Behold the grateful present, the head of your enemy on a platter. I bequeath to you your conquered adversary, and make over death as your legacy (1 Corinthians 3:22). O death, where is thy sting? Where now is the armor in which you trusted (1 Corinthians 15:55)? Come, My people, enter into your chambers (Isaiah 26:20). Come to your beds of dust and lay down in peace; let your flesh rest in hope (Isaiah 57:2); for even in this flesh shall you see God (Psalm 16:8; Job 19:25–27). O you slain by death, your carcasses, now as loathsome as the carrion in the ditch,

I will redeem from the power of the grave (Psalm 49:5), and fashion those vile bodies like unto the glorious body of your exalted Redeemer (Philippians 3:21). Look, if you can, on the sun when it shines in its strength; with such dazzling glory I will clothe you, O ye of little faith (Matthew 13:43).

From the terrible dungeon of eternal darkness I do hereby free you. Fear not, you shall not be hurt by the second death (Revelation 2:11; Romans 8:1); you are delivered from the wrath to come, and shall never come into condemnation (1 Thessalonians 1:10; John 5:24). The flames of Tophet shall not be able to singe the hairs of your heads, no, nor the smell of the fire pass upon you. Stand upon the brink and look down into the horrible pit, the infernal prison, from whence I have freed you. Do you see how the smoke of their torments ascends forever (Revelation 14:11)? Do you hear the cursings and ravings, the roarings and blasphemies (Matthew 25:30)? What do you think of those hellish fiends? Would you have been willing to have had them for your companions and tormentors (Matthew 25:41)? What do you think of those chains of darkness? Of the river of brimstone, of the instruments of torment of both soul and body, of the weeping, wailing, and gnashing of teeth? Can you think of everlasting banishment, of hearing "Go ye cursed"? Could you dwell with everlasting burnings? Could you abide with devouring fire (Isaiah 33:14)? This is the inheritance you were born to (Ephesians 2:3). But I have cut off the entail, and wrought for you a great salvation. I have not ordained you to wrath (1 Thessalonians 5:9), but My thoughts towards you are thoughts of peace (Jeremiah 29:11).

Here I deliver to you your protection. From all your enemies I will save you (2 Kings 17:39). I grant you a protection from the arrests of the law. Your Surety has fully answered it (Galatians 3:13; Romans 5:10). My justice is satisfied, My wrath is pacified, and My honor is repaired (Daniel 2:24; 2 Corinthians 5:19–20). Behold, I am near who justifies you; who is he who shall condemn you?

From the usurped dominion of the powers of darkness I will deliver you. I will tread Satan shortly under you, and will set your feet in triumph upon the necks of your enemies (Romans 16:20). Let not your hearts be troubled; though you are to wrestle with principalities and powers, and the rulers of the darkness of this world (Ephesians 6:12); for stronger is He who is in you than he who is in the world (1 John 4:4). He may bruise your heel, but you shall bruise his head (Genesis 3:15). Behold your Redeemer leading captivity captive, spoiling principalities and powers, triumphing over them openly through His cross (Colossians 2:15). See how Satan falls like lightning from heaven (Luke 10:18), and how the Samson of your salvation bears away the gates of hell, posts and all, upon His shoulders, and sets them up as trophies of His victory; how He pulls out the throat of the lion, lifts up the heart of the traitor upon the top of His spear, washes His hands, and dyes His robes in the blood of your enemies (Isaiah 63:1–3).

From the victory of the world I will deliver you (1 John 5:4; Galatians 1:4). Neither its frowns nor its flatteries shall be too hard for your victorious faith. Though it raises up Egypt, Amalek, Moab, and all its militia against you, yet it shall never keep you out of

Canaan. Be of good comfort, your Lord has overcome
the world (John 16:33). Though its temptations are very
powerful, yet this, upon My faithfulness, I promise you:
nothing shall come upon you but what you shall be
able to bear. But if I see such trials, which you fear
would be too hard for your grace and would overthrow
your soul, I will never allow them to come upon you.
Nay, I will make your enemy to serve you (1 Corinthians
10:13), and I bequeath the world as part of your dowry to
you (1 Corinthians 3:22).

From the curse of the cross I will deliver you (Psalm
119:71). Afflictions shall prove a wholesome cup to you;
your Lord has drunk the venom into His own body, and
what remains for you is but a healthful potion which I
promise shall work for your good (Romans 8:28). Be
not afraid to drink, nor desire that the cup should pass
from you. I bless the cup before I give it to you (Job
5:17). Drink all of it and be thankful; you shall find My
blessing at the bottom of the cup to sweeten the
sharpest afflictions to you (James 1:12; Psalm 94:12). I
will stand by you in all conditions, and be a fast Friend
to you in every change (Isaiah 43:2). In the wilderness I
will speak comfortably to you, and in the fire and water
I will be with you (Hosea 2:14). I will be a strength to
the poor and a strength to the needy in his distress; a
refuge from the storm, and a shadow from the heat,
when the blast of terrible ones is as a storm against the
wall (Isaiah 25:4). Your sufferings shall not be a cup of
wrath, but a grace cup; not a curse, but a cure; not a cup
of trembling, but a cup of blessing to you (Hebrews
12:6–8). They shall not hurt you, but heal you (Psalm
119:67). My blessing shall attend you in every condition
(Genesis 26:3). I say not only 'Blessed shall you be in

your basket, and blessed in your store,' but 'Blessed shall you be in your poverty (Genesis 28:15), and blessed shall you be in your straits'; not only shall you be blessed in your cities and in your fields, but blessed shall you be in your beds and your banishments (Mark 10:29–30). Blessed shall you be when you are persecuted, and when you are reviled and your name is cast about as evil; yea, then doubly blessed (Matthew 5:10–12). My choicest blessings, greatest good, and richest sweets will I put into your evil things (1 Peter 4:13–14; Luke 6:20–22). These happy immunities, these glorious liberties of the sons of God, by this immutable charter I forever settle upon you. And I do, in and with my covenant, unalterably, irrevocably, and everlastingly convey them unto you and confirm them upon you.

Yea, I will not only free you from your miseries, but will confer upon you royal privileges and prerogatives, and instate you into higher and greater happiness than ever you have fallen from. Lo, I give Myself to you, and all things with Myself.

Behold, O you sons of men! Behold and wonder. Be astonished, O heavens! Be moved, you strong foundations of the earth! For you shall be My witnesses. This day I do, by covenant, bestow Myself upon My servants (Genesis 17:7). I will be your God forever and ever (Psalm 48:14; Jeremiah 32:38; Revelation 21:3). Your very own God (Psalm 16:2). Nothing in the world is so much your own as I am. The houses that you have built, or the ones you have bought, are not so much yours as I am. Here you are tenants at will; but I am your eternal inheritance (Psalm 16:5; 73:26). These are loans for a season, but I am your dwelling place in all generations (Psalm 90:1). You have nowhere so great a propriety, so

sure and unalterable a claim, as you have here. What do you count your own? Your bodies, your souls? Nay, these are not your own; they are bought with a price (1 Corinthians 6:19–20). But you may boldly make your claim to Me; you may freely challenge an interest in Me (Jeremiah 3:19; Isaiah 63:16). Come near and fear not; where could you be free if not with your own? Where could you be bold if not at home? You are never in all the world so much at home as when you are with Me. You may freely make use of Me, or of any of My attributes, whenever you need (Psalm 50:15; Jeremiah 49:11; Psalm 145:18).

I will be all to you that you can wish. I will be a friend to you (Isaiah 41:8). My secrets shall be with you (Psalm 25:14; John 15:15), and you shall have free access to Me, and liberty to pour out all your hearts into My bosom (Ephesians 3:12; Hebrews 4:16).

I will be a physician to you. I will heal your backslidings and cure all your diseases (Hosea 14:4; Psalm 103:3). Fear not, for never did a soul miscarry that left itself in My hands, and would follow My prescriptions.

I will be a shepherd to you (Psalm 23:1; 80:1). Be not afraid of evil tidings, for I am with you. My rod and My staff shall comfort you. You shall not want, for I will feed you; you shall not wander or be lost, for I will restore you. I will cause you to lie down in green pastures, and will lead you beside the still waters (Psalm 23). I will gather you with My arm, carry you in My bosom, and will lead on as softly as the flock and the children are able to endure (Isaiah 40:11; Genesis 33:13–14). If officers are careless, I will do the work Myself. I will judge between cattle and cattle. I will seek that which was lost, and bring again that which was driven away. I will bind

up that which was broken, and strengthen that which was sick; but I will destroy the fat and the strong, and will feed them with judgment (Ezekiel 34:16–17 compared with verses 2–4). I will watch over My flock by night (Isaiah 27:3). Behold, I have appointed My ministers as your watchmen, as overseers who watch for your souls (Hebrews 13:17; Acts 20:28). Yea, My angels shall be your watchers, and shall keep a constant guard upon My flock (Daniel 3:17; Psalm 34:7). And if the servants should sleep (Matthew 13:25, 27), My own eyes shall keep a perpetual watch by night and by day (Psalm 34:15; 33:18; 2 Chronicles 16:9). The Keeper of Israel never slumbers nor sleeps (Psalm 121:3–5), nor withdraws His eyes from the righteous (Job 36:7). I will guide you with My eye. I will never trust you out of My sight (Psalm 32:8).

I will be a Sovereign to you. The Lord is your Judge; the Lord is your Lawgiver; the Lord is your King (Isaiah 33:22). Do not fear the unrighteousness of men, for I will judge your cause and defend your rights (Deuteronomy 32:36; Psalm 140:12 and 9:4). You shall not stand at man's bar; you shall not be cast out by their vote (1 Corinthians 4:3–5; 2 Corinthians 10:18). Let them curse; I will bless. Let them condemn; I will justify (Isaiah 50:9; Genesis 12:3).

When you come upon trials in your lives, such as will decide your eternal state, you shall see your Friend and your Father upon the bench (Psalm 80:9; Ecclesiastes 3:16–17). Into My hands shall your cause be cast, and you shall surely stand in judgment and be found at the right hand among the sheep. You shall hear the King say, "Come, ye blessed; inherit the kingdom" (Matthew 25:33–34).

I will be a husband to you (Isaiah 54:5). In lovingkindness and mercy I will betroth you unto Myself forever (Hosea 2:19–20). I will espouse your interest, and will be as one with you, and you with Me (Matthew 25:40, 45; Acts 9:4–5). You shall be for Me and not for another; and I also will be for you (Hosea 3:3). Though I found you as a helpless infant, exposed in its own blood, all your unworthiness did not discourage Me. Lo, I have looked upon you, and put My comeliness upon you. Moreover, I swear unto you, and enter into covenant with you, and you shall be Mine (Ezekiel 16:4–10). Behold, I do, as it were, put Myself out of My own power, and do here solemnly, in My marriage covenant, make away Myself to you (Jeremiah 24:7; 30:21–22; 31:33–34), and with Myself all things (Revelation 21:7). I will be an everlasting portion to you (Jeremiah 51:19; Psalm 119:57). Now lift up your eyes to the east, to the west, to the north, and to the south. Have you not a worthy portion, a goodly heritage? Can you cast up your riches or count your own happiness? Can you fathom immensity, reach omnipotence, or comprehend eternity? All this is yours. I will set open all My treasures to you, and will keep back nothing from you.

All the attributes in the Godhead, and all the persons in the Godhead, do I hereby make over to you. I will be yours in all My essential perfections and in all My personal relations.

*In all My essential perfections:* My eternity shall be the date of your happiness. I am the eternal God, and while I am, I will be life and blessedness to you (Psalm 90:1–2 compared with 48:14; 1 Timothy 1:17 compared with 1 Peter 5:10). I will be a never-failing fountain of joy, peace, and bliss unto you (Psalm 36:7–9; 16:11; Isaiah

35:10). I am the first and last, who was and is and is to come. And My eternal power and Godhead shall be bound to you (Jeremiah 32:40).

I will be your God, your Father, and your Friend as long as I have any being (Isaiah 9:6; Jeremiah 10:10). I have made My everlasting choice in pitching upon you (Psalm 132:13–14; Hosea 2:19). Fear not, for the eternal God is your refuge, and underneath you are the everlasting arms (Deuteronomy 33:27). My durable riches and righteousness shall be yours (Proverbs 8:18). Though all should forsake you, yet will I not forsake you (Hebrews 13:5; Psalm 27:10). When the world, and all that is therein, shall be burned up, I will be a standing portion for you. When you are forgotten among the dead, I will remember you with everlasting lovingkindness (Isaiah 54:10).

My unchangeableness shall be the rock of your rest (Psalm 62:6–7). When all the world is like a tumbling ocean round about you, here you may fix and settle. I am your resting place (Jeremiah 50:6; 2 Chronicles 14:11).

The immutability of My nature, of My counsel and of My covenant, are sure footing for your faith, and a firm foundation for your strong and everlasting consolation (2 Timothy 2:19; Hebrews 6:17–18). When you are afflicted, tossed with tempests (Isaiah 54:11), and not comforted, put in to Me. I am a haven of hope. I am a harbor of rest for you. Here cast your anchors, and you shall never be moved (Jeremiah 17:13, 17; Psalm 46:1–2, 5; 125:1).

My omnipotence shall be your guard. I am God Almighty, your almighty Protector, your almighty Benefactor (Genesis 15:1; 17:1). What if your enemies

are many? More are they who are with you than they
who are against you; for I am with you (2 Chronicles
32:7–8; 2 Kings 6:16). What if they are mighty? They are
not almighty. Your Father is greater than all, and none
shall pluck you (whatever else they might pluck) out of
My hands (John 10:29). Who can hinder My power or
obstruct My salvation (Isaiah 43:13; Daniel 4:35)? Who is
like unto the God of Jeshurun, who rides on the heaven
for your help, and in His excellency on the sky? I am
the sword of your strength and the shield of your excel-
lency (Deuteronomy 33:26, 29). I am your rock and your
fortress, your deliverer, your strength, the horn of your
salvation, and your high tower (Psalm 18:2). I will main-
tain you against all the power of the enemy. You shall
never sink if Omnipotence can support you (1 Peter
1:5). The gates of hell shall not prevail against you
(Matthew 16:18). Your enemies shall find hard work of
it. They must first overcome victory, enervate Omnipo-
tence, corrupt fidelity, or change immutability before
they can finally prevail against you; either they shall
bow or break (Revelation 3:19; Isaiah 66:24). Though
they should exalt themselves as the eagle, though they
should set their nest among the stars, even there will I
bring them down (Obadiah 4; Jeremiah 49:16).

My faithfulness shall be your security (Psalm 89:33–
35). My truth, yea, My oath shall fail if ever you come to
be losers by me (Isaiah 54:9–10 compared with Mark
10:29–30). I will make you to confess, when you see the
results and upshot of all My providences, that I was a
God worthy of being trusted, worthy of being believed,
worthy of being rested in and relied upon (Psalm 34:4–
6, 8; 84:12; 146:5; Jeremiah 17:7–8; Psalm 22:4–5). If you
do not walk in My judgments, you must look for My

threats and frowns, yea, and blows too; and you will see that I am not jesting with you, nor will I indulge you in your sins (Psalm 89:30–32; Amos 3:2; 2 Samuel 12–15; 1 Peter 4:7). Nevertheless, My lovingkindness I will never take from you, nor suffer My faithfulness to fail. My covenant I will not break, nor alter the thing that has gone out from My lips.

My mercies shall be your store (Isaiah 53:7; Psalm 119:41). I am the Father of mercies, and such a Father I will be to you (2 Corinthians 1:3). I am the fountain of mercies, and this fountain shall ever be open to you (Psalm 36:9 compared with Revelation 21:6).

My mercies are very many, and they shall be multiplied towards you (Nehemiah 9:17 compared with Isaiah 55:7); very great, and they shall be magnified upon you (1 Chronicles 21:13 compared with Genesis 19:19); very sure, and they shall forever be sure to you (Isaiah 55:3); very tender, and they shall be infinitely tender of you (Psalm 119:156 compared with Psalm 103:4). Though the figtree does not blossom, nor the vine bear fruit, nor the flock bring forth, fear not, for My compassions fail not (Habakkuk 3:17; Lamentations 3:22). Surely goodness and mercy shall follow you all the days of your lives (Psalm 23:6). Even to your old age I am He, and even to hoary hairs will I carry you. I have made you, and I will bear you, carry you, and deliver you (Isaiah 46:4). I will make an everlasting covenant with you, that I will not turn away from you to do you good (Jeremiah 32:40). I swear that I will show you the kindness of God (1 Samuel 20:14–17). I can as soon forget to be God as forget to be gracious. While My name is Jehovah—merciful, gracious, long-suffering, abundant in goodness and truth—I will never forget to show

mercy to you (Psalm 102:17 compared with 34:6–7). All My ways towards you shall be mercy and truth (Psalm 25:10). I have sworn that I would not be wroth with you nor rebuke you; for the mountains shall depart and the hills removed, but My kindness shall not depart from you, neither shall the covenant of My peace be removed. Thus says the Lord who has mercy on you.

My omniscience shall be your overseer. My eyes shall ever be open, observing your wants to relieve them, and your wrongs to avenge them (1 Peter 3:12; Exodus 3:7). My ears shall ever be open to hear the prayers of My poor, and the cries of My oppressed, the clamors, calumnies, and reproaches of your enemies (Psalm 34:5; Exodus 2:24–25; Zephaniah 2:8–10). Surely I have seen your affliction and know your sorrows. And shall not God avenge His own elect? I will avenge them speedily (Luke 18:7–8). I see the secret plots and designs of your enemies against you (Jeremiah 18:23), and will disannul their counsels (Isaiah 8:10 with 29:14–15; Psalm 33:10). I see your secret integrity, and the uprightness of your hearts towards Me, while the carnal and censorious world condemns you as hypocrites (Job 1:8–11; 2 Chronicles 15:17). Your secret prayers, fasts, and tears, which the world knows not of, I observe and record them (Matthew 6:6, 18; Acts 10:4). Your secret care to please Me, the secret pains within your hearts, your secret self-searchings and self-denial—I see them all, and your Father, who sees in secret, shall reward them openly (Matthew 25:34–36; 2 Chronicles 34:27).

My wisdom shall be your counselor. If any lacks wisdom, let him ask of Me, and it shall be given him (James 1:5). I will be your deliverer. When you are in darkness, I will be a light to you. I will make your way

plain before you (Isaiah 48:19; 57:14). You are short-sighted, but I will be eyes to you (Isaiah 52:6–7; 29:6)). I will watch over you, to bring upon you all the good I have promised (Jeremiah 31:28 with 32:24), and to keep off all the evil you fear, or at least turn it into good (Psalm 91:10, 14; Jeremiah 24:5). You shall have your food in its season and your medicine in its season; mercies, afflictions, and everything suitable, all in their season (Psalm 23:2–3; 1 Peter 1:6; Isaiah 27:7–9).

I will outwit your enemies and make their oracles to speak but folly (Isaiah 19:11–15). The old serpent shall not deceive you. I will acquaint you with his devices (2 Corinthians 2:11). The deceitful hearts you fear shall not undo you. I will reveal their wiles.

I know how to deliver the godly out of temptation, and to reserve the unjust to the day of judgment to be punished (2 Peter 2:9). Trust in Me with all your hearts, and do not lean on your own understanding (Proverbs 3:5). I am God, who performs all things for you (Psalm 57:2). I will forfeit the reputation of My wisdom if I do not make you to acknowledge, when you see the end of the Lord (James 5:11)—though at present you wonder at and do not understand the meaning of My proceedings—that all My works are in weight, in number, in time, and in order (Ecclesiastes 3:14); if I do not cause you to cry out, "Manifold are Thy works; in wisdom hast Thou made them all" (Psalm 33:4; 104:24; 145:10).

My justice shall be your revenger and rewarder (2 Thessalonians 1:6; 2 Timothy 4:8). Fear not to approach; fury is not in Me (Isaiah 27:4). My justice is not only appeased towards you, but engaged for you. I am so fully satisfied in the sacrifice of My beloved Son that justice itself, which was as a flaming sword drawn

against you, now greatly befriends you; and that which
was an amazing, confounding terror shall now become
your relief and consolation (Ecclesiastes 3:16–17; 5:8;
Psalm 96:10–13; 97:1 with 99:1). Under all your oppres-
sions, here shall your refuge be (Psalm 6:9; 103:6). Let
me know your grievances, and My justice will right your
wrongs and reward your services (Psalm 146:7; Hebrews
6:10). You may conclude upon your pardons, conclude
upon your crowns, conclude upon reparation for all
your injustices, and all from the sweet consideration of
My justice (1 John 1:9; 2 Timothy 4:8; 1 Peter 2:23), the
thought of which to others is as the horror of the
shadow of death. If you sin, despair not; remember, I
am just to forgive you. If you are at any pains or cost for
Me, do not count it as lost, for I am not unrighteous to
forget you. I am the righteous Judge who has laid up for
you, and will set upon you, the crown of righteousness.
Are you reviled, persecuted, or defamed? Forget not that
I am righteous to render tribulation to those who trou-
ble you; and to you who are troubled, rest in Me.
Though all your services and sufferings do not deserve
the least good at My hands, yet as I have freely passed
My promise to reward them, so I will as justly keep it.

My omnipresence shall be company for you
(1 Chronicles 22:18; Joshua 1:5, 9; Isaiah 41:10). Surely I
will be with you to bless you. No bolts, no bars, no
bonds, nor banishment shall remove you from Me, nor
keep My presence and the influences of heaven from
you (Genesis 39:21, 23). I am always with you (Matthew
28:20); in your darkest nights, in your deepest dangers, I
am close at hand, a very present help in the time of
trouble (Psalm 46:1; 34:18). I am not a God who is afar
off or asleep or on a journey when you need My coun-

sel, My ear, or My aid. I am always nigh unto those who
fear Me.

No Patmos, no prison shall hinder the presence of
My grace from you (Revelation 1:9–10; Acts 16:25–26).
My presence shall perfume the smelliest wards, and
lighten the darkest dungeon where you can be thrust
(Acts 13:7; Isaiah 58:10).

My holiness shall be a fountain of grace to you
(John 1:16; 2 Peter 1:4). I am the God of hope (Romans
15:13), the God of love (2 Corinthians 13:11), the God of
patience (Romans 15:5), the Author and Finisher of
faith (Hebrews 12:2), the God of all grace (1 Peter 5:10),
and I will give grace to you (Psalm 84:11). My design is
to make you partakers of My holiness (Hebrews 12:10). I
will be a constant spring of spiritual life to you
(Galatians 2:20; John 14; John 8:12; 10:10). The water
that I shall give you shall be in you as a well of water,
springing up into everlasting life (John 4:14). The seed
of life that I shall put into you shall be so fed and cher-
ished, and maintained by My power, that it shall be
immortal (1 John 3:9; 1 Peter 1:23; Colossians 2:19). The
unction that you shall receive from the Holy One shall
abide in you and teach you all things necessary for you;
and as it has taught you, you shall abide in Him (John
14:16–17; 1 John 2:20, 27). Only keep the pipes open,
and apply the means which I have prescribed, and you
shall flourish in the courts of your God (Proverbs 8:34;
Psalm 92:13). Yea, I will satisfy your souls in drought
and make your bones fat, and you shall be like a wa-
tered garden. Lo, I will be as the dew unto you, and you
shall grow as the lily and cast forth your roots as
Lebanon. Your branches shall spread and your beauty
shall be as the olive tree (Hosea 14:5–6). You shall still

bring forth fruit in an old age; you shall be fat and flourishing.

My sovereignty shall be commanded by you (Genesis 32:26–28). You shall be My favorites, men of power to prevail with Me (Hosea 12:4; James 5:17–18). All My attributes shall be at the command of your prayers (Isaiah 45:11).

In summary, My all-sufficiency shall be the lot of your inheritance (Genesis 17:1; Lamentations 3:24; Psalm 16:5–6). My fullness is your treasure (Numbers 18:20; Deuteronomy 10:9). My house is your home (Psalm 91:1, 9). You may come as freely to My store as to your own cupboard (Ephesians 3:12). You may have your hand as freely in My treasures as in your own purses. You cannot ask too much; you cannot look for too much from Me (Ephesians 3:20; Matthew 7:8). I will give you (or will be Myself to you instead of) all comforts (Genesis 15:1; Psalm 84:11). You shall have children, or I will be better to you than ten children (Isaiah 56:5). You shall have riches, or I will be more to you than all riches (2 Corinthians 6:10).

You shall have friends, if best for you, or else I will be your Comforter in your solitude (Isaiah 51:3; John 14:26; 2 Corinthians 1:3–4), your Counselor in your distress (Psalm 73:24). If you leave father, mother, houses, or lands for My sake, you shall have a hundredfold in Me, even in this time (Mark 10:30). When your enemies shall remove your comforts, it shall be but as letting the cistern run and opening the fountain, or putting out the candles and letting in the sun. The swelling waters shall raise higher the ark of your comfort (Romans 5:3; Hebrews 10:34; Acts 5:41). I will be the staff of bread to you, your life, and the strength of your days (Deuteron-

omy 30:20; Isaiah 33:16). I will be a house and a home to you; you shall dwell with Me, yea, dwell in Me and I in you (Deuteronomy 33:12; John 14:23; 1 John 3:24). I will stand and fall with you (Psalm 37:17, 24; 54:4; Isaiah 41:10). I will repair your losses and relieve your needs (Philippians 4:19; Mark 8:35; Matthew 19:27–29).

Can you burn out the lamp of heaven, or empty the boundless ocean with your hands? Why, the sun shall be dark and the sea dry before the Father of lights, the Fountain of mercies shall be exhausted. Behold, though the world has been spending upon the stock of My mercy ever since I created man upon earth, yet it runs with a full stream still. My sun diffuses its rays and disburses its light, and yet it shines as bright as ever; much more can I dispense of My goodness and fill My creatures' brim full and running over, and yet have never the less in Myself. And until this self-sufficiency is spent, you shall never be undone. I am the God of Abraham, Isaac, and Jacob, and whatever I was to them I will be to you.

Are you in want? You know where to go. I am ever at home; you shall not go away empty from My door. Never distract yourselves with cares and fears, but make known your requests by prayer and supplication to Me (Philippians 4:6). I will help when all others fail (Psalm 73:26; Isaiah 63:5; Psalm 102:17). When friends and hearts fail; when your eyestrings and heartstrings crack; when your acquaintances and souls leave you, My bosom shall be open to you (Psalm 49:15; 2 Corinthians 5:1; Luke 16:22). I will lock up your dust and will receive your souls.

And My infiniteness shall be the extent of your inheritance. Can you by searching find out God? Can you

find out the Almighty to perfection? He is as high as
heaven; what can you do? He is deeper than hell; what
can you know (Job 11:7–8)? This incomprehensible
height, this unfathomable depth, shall be all yours,
forever yours.

I am your inheritance, which no line can measure,
no arithmetic can value, and no surveyor can describe
(Ezekiel 44:28; Ephesians 3:8; 1 Timothy 6:16; Psalm
145:3). Lift up your eyes now to the ancient mountains,
to the utmost bounds of the everlasting hills; all that
you can see is yours. But your short sight cannot per-
ceive half of what I give you. And when you see and
know most, you are no less than infinitely short of the
discovery of your own riches (Job 26:14).

Yea, further, I will be yours in all My personal rela-
tionships.

I am the everlasting Father, and I will be a Father to
you (John 20:17). I take you for My sons and daughters
(2 Corinthians 6:18). Behold, I receive you not as ser-
vants, but as sons to abide in My house forever (John
8:35–36). Whatever love or care children may look for
from their father, that you may expect from Me
(Matthew 6:31–32), and so much more since I am wiser,
greater, and better than any earthly parents. If earthly
fathers will give good things to their children, much
more will I give to you (Luke 11:13). If such cannot for-
get their children, much less will I forget you (Isaiah
49:15). What would My children have? Your Father's
heart, His house, His care, His ear, His bread, and His
rod? These shall all be yours.

You shall have My fatherly affection. My heart I
share among you. My tenderest loves I bestow upon you
(1 John 3:1; Jeremiah 31:3; Isaiah 54:8).

You shall have My fatherly compassion. As a father pities his children, so will I pity you (Psalm 103:13–14). I will consider your frame, and not be extreme to mark what is done amiss by you, but will cover all with the mantle of My excusing love (Psalm 78:39).

You shall have My fatherly instruction. I will cause you to hear the sweet voice behind you, saying, "This is the way" (Isaiah 30:21). I will tender your weaknesses, and inculcate My admonitions, line upon line, and will feed you with milk when you cannot digest stronger meat (Isaiah 28:13; 1 Corinthians 3:2). I will instruct you and guide you with My eyes (Psalm 32:8).

You shall have My fatherly protection. In My fear is strong confidence, and My children shall have a place of refuge (Proverbs 14:26). My name shall be your strong tower, to which you may at all times fly and be safe (Proverbs 18:10). To your stronghold, you prisoners of hope (Zechariah 9:12). I am an open refuge, a near and inviolable refuge for you (Psalm 48:3; Deuteronomy 4:7; John 10:29).

You shall have My fatherly provision. Do not be afraid of want; in your Father's house there is bread enough (Psalm 34:9; Luke 15:17). I will care for your bodies. Do not worry about what you shall eat, drink, or put on. Let it suffice you that your heavenly Father knows that you have need of all things (Matthew 6:25–34; Luke 12:22–32). I will provide for your souls: meat for them, mansions for them, and portions for them (John 6:30–59; Lamentations 3:23).

Behold, I have spread the table of My gospel for you, with privileges and comforts that no man can take from you (Isaiah 25:6; Matthew 22:4; Proverbs 9:2). I have set before you the bread of life, the tree of life, and the

water of life (John 6:48; Revelation 2:7 and 22:17). Eat, O
friends; drink abundantly, O beloved!

But all this is but a taste of what I have prepared. You
must have but smiles and hints now, and be content
with glimpses and glances here. But you shall be
shortly taken up into your Father's bosom and live for-
ever in the fullest views of His glory (1 Thessalonians
4:17).

You shall have My fatherly probation. I will chasten
you because I love you, so that you may not be con-
demned with the world (1 Corinthians 11:32; Proverbs
3:11–12).

My Son I give unto you in a marriage covenant for-
ever (Isaiah 9:6; 2 Corinthians 11:2). I make Him over to
you as wisdom for your illumination, righteousness for
your justification, sanctification for curing your corrup-
tions, and redemption for deliverance from your ene-
mies (1 Corinthians 1:30). I bestow Him upon you with
all His fullness, all His merits, and all His graces. He
shall be yours in all His offices. I have anointed Him
for a prophet. Are you ignorant? He shall teach you. He
shall be eyesalve to you (Isaiah 49:6 and 42:16; Revela-
tion 3:18). I have sent Him to preach the gospel to the
poor and to recover sight for the blind, to set at liberty
those who are bruised (Luke 4:18). I have established
Him by oath as a priest forever (Psalm 110:4). If you sin,
He shall be your Advocate. He shall expiate your guilt
and make the atonement (1 John 2:1–2; Zechariah
13:1). Have you any sacrifice, any service to offer? Bring
it to Him, and you shall receive an answer of peace
(1 Peter 2:5; Hebrews 13:15).

Present your petitions to Me by Him, for He will I
accept (John 16:23–24). Having such a High Priest over

the house of God (Hebrews 10:19–22), you may come to Me with boldness, you may come and be welcome. I have set Him up as King upon My holy hill of Zion. He shall rule you and defend you (Isaiah 9:6–7). He is the King of righteousness, the King of peace; and such a King He shall be to you (Hebrews 7:2; Jeremiah 23:6; Ephesians 2:14). I will set up His standard for you (Isaiah 49:22). I will set up His throne in you (Psalm 110:2). He shall reign in righteousness and rule in judgment, and He shall be a hiding place from the wind, a covert from the tempest, and the shadow of a great rock in a weary land (Isaiah 32:1–2). He shall hear your causes, judge your enemies (Isaiah 11:3–5), and reign till He has put all under His feet (Psalm 110:1; 1 Corinthians 15:25), yea, and under your feet; for they shall be as ashes under you, and you shall tread them, said the Lord of hosts (Malachi 4:3). Yea, I will undo those who afflict you, and all those who despised you shall bow themselves down at the soles of your feet (Isaiah 60:14; Zephaniah 3:19). And you shall go forth and behold the carcasses of the men who have trespassed against Me, for their worm shall not die, neither shall their fire be quenched; and they shall be an abhorring to all flesh (Isaiah 66:24).

My Spirit I give unto you as your Counselor and Comforter (John 16:7; Romans 8:14). He shall be a constant inmate with you, and shall dwell in you and abide with you forever (Ezekiel 36:27; John 14:16–17).

I consecrate you as temples to His holiness (1 Corinthians 3:16–17 and 6:19). He shall be your guide. He shall lead you into all truth (Galatians 5:18; John 16:13). He shall be your Advocate to indite your prayers and make intercession for you; and He shall fill

your mouths with the arguments that He knows will prevail with Me (Romans 8:26–27). He shall be oil to your wheels, strength to your ankles, wine to your hearts, marrow to your bones, and wind to your sails. He shall witness your adoption (Romans 8:16). He shall seal you up to the day of redemption, and be to you the earnest of your inheritance until the redemption of the purchased possession (Ephesians 4:30; 1:13–14; 2 Corinthians 1:22).

And as I give you Myself, so much more all things with Myself (Romans 8:32): earth and heaven, life and death, things present and things to come (1 Corinthians 3:22).

Things present are yours. Lo, I give you Caleb's blessing, the upper springs and the nether springs. I will bless you with all spiritual blessings in heavenly places in Christ (Ephesians 1:3).

To you pertains the adoption, the glory, the covenants, the service of God, and the promises (Romans 9:4). To you I will give the white stone and the new name (Revelation 2:17), access into My presence (Ephesians 3:12), the acceptance of your persons (Ephesians 1:6), and audience to your prayers (1 John 5:14–15).

Peace I leave with you. My peace I give unto you (John 14:27). I will undertake for your perseverance, keep you to the end, and will then crown My own gift with eternal life (Jeremiah 32:40; John 10:28–29; 1 Peter 1:5; Philippians 1:6). I have made you heirs of God and coheirs with your Lord Jesus Christ; and you shall inherit all things (Romans 8:17; Revelation 21:7).

I have granted you My angels as your guardians. The courtiers of heaven shall attend upon you; they shall be

all ministering spirits for your good (Hebrews 1:14). Behold, I have given them charge over you, upon their fidelity to look after you, and, as tender nurses, to bear you in their arms and keep you from coming to any harm (Psalm 91:11–12). These shall be as careful shepherds to watch over My flock by night and to encamp round about My fold (Psalm 34:7).

My ministers I give as your guides (Ephesians 4:11). Paul, Apollos, Cephas, all are yours (1 Corinthians 3:22). I am always with them, and they shall be with you always, to the end of the world (Matthew 28:20; Ephesians 4:13). You shall have pastors after My own heart (Jeremiah 3:15 and 23:4). And this shall be My covenant with you: " 'My Spirit which is upon you, and My words which I have put into your mouth, shall not depart out of your mouth, nor the mouth of your seed, nor of your seed's seed,' saith the Lord, 'from henceforth and forever' "(Isaiah 59:21).

In short, all My officers shall be for profiting and perfecting you (Ephesians 4:12). All My ordinances shall be for edifying and saving you (Acts 10:33; Romans 1:16). The very severities of My house, admonitions and censures, and the whole discipline of My family, shall be for preventing your infection, curing your corruption, and procuring your salvation (1 Corinthians 5:5–7; Matthew 18:15).

My Word I have ordained for converting your soul, enlightening your eyes, rejoicing your hearts, cautioning you of danger, cleansing your defilements, and conforming you to My image (Psalm 19:7–9; Ephesians 5:26; 2 Corinthians 3:18). To you I commit the oracles of God (Romans 3:2). Here you shall be furnished against temptations (Matthew 4:4, 7; Ephesians 6:17); hence you

shall be comforted under distresses and afflictions (Psalm 119:92–93). Here you shall find My whole counsel (Acts 20:27). This shall instruct you in your way, correct you in your wanderings, direct you into the truths to be believed, and detect to you the errors to be rejected (2 Timothy 3:16; Psalm 119:105).

My sacraments I give you as the pledges of My love. You shall freely claim them; they are children's bread. Lo! I have given them as seals to certify all that I have here promised you (Romans 4:11); and when these sacred signs are delivered unto you, then know and remember and consider in your hearts that I therein pledge you My troth, set to My hand, and thereby ratify and confirm every article of these indentures, and do actually deliver into your own hands this glorious charter, with all its immunities and privileges as your own forever (1 Corinthians 11:25; Genesis 17:10).

And since I have sown to you so largely in spiritual blessings, shall you not much more reap the temporal? Do not be of a doubtful mind; all these things shall be added unto you (Luke 12:29–31). My creatures I grant for your servants and supplies (Psalm 8:3–9). Heaven and earth shall minister to you. All the stars in their courses shall serve you, and, if need be, shall fight for you (Judges 5:20). I will make My covenant for you with the beasts of the field and with the fowls of heaven; and you shall be in league with the stones of the field, and all shall be at peace with you (Job 5:23; Hosea 2:18). I will undertake for all your necessities. Do I feed the fowls and clothe the grass, and do you think I will neglect My children (Matthew 6:25–34)? I hear the young ravens when they cry, and shall I not much more fulfill the desires of those who fear Me (Psalm 145:19 and

147:9)? Fear not, you shall surely lack no good thing (Psalm 34:10); and you would not desire riches, pleasures, or preferment to your harm. I will give meat to those who fear Me. I will be ever mindful of My covenant (Psalm 111:5).

My providences shall cooperate for your good (Romans 8:28). The cross winds shall blow you sooner and more swiftly to your harbor. You shall be preferred when you seem most debased, and be the greatest gainers when you seem to be the deepest losers. I will most effectually promote your good when you seem most to deny it (2 Corinthians 4:17; Mark 10:29–30; Philippians 1:29). Things to come are yours: the perfecting of your souls, the redemption of your bodies, and the consummation of your bliss.

When you have glorified Me for awhile on earth, and finished the work I have given you to do, you shall be caught up into paradise and rest from your labors, and your works shall follow you (Revelation 14:13; Luke 23:43). I will send My own lifeguard to bring home your departing souls (Luke 16:22), and will receive you among the spirits of just men made perfect (Hebrews 12:23). And you shall look back upon Pharaoh and all his host, and see your enemies dead upon the shore. Then shall be your redemption from all your afflictions, and all your corruptions (Luke 21:28; Ephesians 4:30). The thorn in the flesh shall be pulled out and the hour of temptation shall be over, and the tempter out of work forever.

The sweat shall be wiped off your brows, the day of cooling and refreshing shall come, and you shall sit down forever under My shadow (Acts 3:19; Hebrews 4:9). For the Lamb who is in the midst of the throne shall

feed you, and lead you to the living fountains of water
(Revelation 7:17). The tears shall be wiped away from your eyes, and
there shall be no more sorrow nor crying, neither shall
there be any more pain; for the former things are
passed away, and, behold, I make all things new
(Revelation 21:4–5). I will change Marah into Naomi,
the cup of sorrow into the cup of salvation; and the
bread and water of affliction I will change into the wine
of eternal consolation (John 16:20–22; Luke 6:21). You
shall take down your harps from the willows, and I will
turn your tears into pearls and your penitential psalms
into songs of deliverance. You shall change your
Ichabods into hosannas, and your ejaculations of sor-
row into hallelujahs of joy (Revelation 19:1, 4, 6).

The cross shall be taken off your backs, and you
shall come out of your great tribulations and wash your
robes, making them white in the blood of the Lamb;
and you shall be before the throne of God, and serve
Him night and day in His temple. He who sits on the
throne shall dwell among you, and you shall hunger
and thirst no more, neither shall the sun light upon
you, nor any heat (Revelation 7:14–16).

The load shall be taken from your consciences. Sins
and doubts shall no more defile or distress you
(Revelation 22:17; Hebrews 12:23). I will make an end of
sin, and will knock off the fetters of your corruptions.
And then you shall be a glorious church, not having
spot or wrinkle, or any such thing, but holy and with-
out blemish.

Thus shall you be brought to the King all glorious
in raiment of needlework and clothing of gold; with
gladness and rejoicing shall you be brought, and enter

into the King's palace (Psalm 45:9, 13–15). So shall the beloved of the Lord dwell safely by Him, and you shall stand continually before Him, beholding the beauty of the Lord and hearing His wisdom (1 Corinthians 13:12). Then will I open in you an everlasting spring of joy, and you shall break forth into singing. You shall never cease nor rest, day or night, saying, "Holy, holy, holy" (Revelation 4:8; Psalm 16:11).

Thus shall the grand enemy expire with your breath, and the body of death be put off with your dying body. The day of your death shall be the birthday of your glories (Philippians 1:23; Luke 23:43).

Have faith in God (Mark 11:22). Wait but a little, and sorrow shall cease and sin be no more. And then a little longer and death shall be no more (Revelation 20:14 and 21:4). Your last enemy shall be destroyed and your victory completed. Yet a little while and He who shall come will come, and you also shall appear with Him in glory (Hebrews 10:37; Colossians 3:4). This same Jesus, who was taken from you into heaven, shall so come as He went up into heaven (Acts 1:11); and, when He comes, He will receive you to Himself, that where He is there you may be also (John 14:3). Behold His sign: He comes in the clouds of heaven with power and great glory; and every eye shall see Him, and all the tribes of the earth shall mourn because of Him (Revelation 1:7; Matthew 24:30); but you shall lift up your heads because the day of your redemption draws nigh (Luke 21:28). Then He shall sound His trumpet (1 Corinthians 15:52; 1 Thessalonians 4:16), and make you hear His voice in your dust (John 5:28), and shall send His mighty angels to gather you from the four winds of heaven (Matthew 24:31), who shall carry you in the triumphant chariot of

the clouds to meet your Lord. And you shall be prepared for Him, and presented to Him, as a bride adorned for her husband (Revelation 2:2). And as you have borne the image of the earthly, so you shall bear the image of the heavenly; and you shall be fully conformed both in body and spirit to your glorious Head (Philippians 3:21; Hebrews 12:2–3). Then shall He confess you before His angels (Revelation 3:5), and you shall receive your open absolution before all flesh, and be owned, approved, and applauded in the public audience of the general assembly (Matthew 10:32 and 25:32–35). And you shall be, with all royal solemnities, espoused unto the King of glory, in the presence of all His shining courtiers (Revelation 19:7–8; 2 Corinthians 4:14; Matthew 25:31), to the envy, gnashing, and terror of your adversaries (Luke 13:28).

So shall your Lord with His own hand crown you (Revelation 2:10), and set you on thrones (Revelation 3:21; Matthew 19:28); and you shall judge men and angels (1 Corinthians 6:2–3), and you shall have power over the nations (Revelation 2:26–27), and you shall set your feet upon the necks of your enemies (Psalm 49:14).

Lo, I have set the very day for your installment (Acts 17:31). I have provided your crowns (2 Timothy 4:8), and have prepared the kingdom (Matthew 25:34). Why do you doubt, O ye of little faith? These are the true sayings of your God (Revelation 19:9). Are you sure that you are now on earth? So surely shall you be shortly with Me in heaven. Are you sure that you shall die? So surely shall you rise again in glory. Lo, I have said it, and who shall reverse it? You shall see Me face to face, be with Me where I am, and behold My glory (1 Corinthians 13:12; John 17:24). For I will be glorified

in My saints, and admired by all those who believe
(2 Thessalonians 1:10); and all flesh shall know that I
have loved you (Revelation 3:9). For I will make you the
examples of My grace (Ephesians 1:5–6 and 2:7), in
whom the whole world shall see how unutterably the
Almighty God can advance the poor worm's meat and
dust of the ground. And the despisers shall behold and
wonder and perish (Acts 13:41), for they shall be wit-
nesses to the riches of My magnificence, and the ex-
ceeding greatness of My power (Luke 16:23). They shall
go away into everlasting punishment, but you into life
eternal (Matthew 25:46).

For no sooner shall their doom be past but the
bench shall rise (Matthew 25:41, 46), and the Judge
shall return with all His glorious train; with sound of
trumpet and incredible shouts He shall ascend, and
shall lead you to your Father's house (Psalm 45:14–15;
Matthew 25:23; John 14:2; 2 Corinthians 5:1). Then shall
the triumphal arches lift up their heads, and the ever-
lasting gates shall open; the heavens shall receive you
all, and so shall you ever be with the Lord (John 12:26;
1 Thessalonians 4:17).

And now I will rejoice over you with singing, and
you will rest in My love. Heaven shall ring with joys and
acclamations, because I have received you safe and
sound (Luke 15:20–27). And in that day you shall know
that I am a Rewarder of those who diligently seek Me
(Hebrews 11:6), and that I recorded your words
(Malachi 3:16), bottled your tears, watched your wander-
ings (Psalm 56:8), and kept an account, even to a cup of
cold water, of whatever you said or did for My name
(Matthew 10:42). You shall surely find that nothing is
lost (1 Corinthians 15:58), but you shall have full

measure, pressed down and running over, thousands of years in paradise for the least good thought, and thousands and thousands more for the least good word. And then the reckoning shall begin again, till all arithmetic is non-plussed. For you shall be swallowed up in a blessed eternity; the doors of heaven shall be shut upon you, and there shall be no more going out (Daniel 12:2-3; Revelation 3:12; Luke 16:26).

The glorious choir of My holy angels, the goodly fellowship of My blessed prophets, the happy society of triumphant apostles, the royal hosts of victorious martyrs—these shall be your companions forever (Matthew 8:11-12; Hebrews 12:22-23). And you shall come in white robes, with palms in your hands, everyone having the harps of God and golden vials full of odors, and shall cast your crowns before Me, and strike in with the multitude of the heavenly hosts, glorifying God and saying, "Hallelujah! The Lord God omnipotent reigneth (Revelation 7:9-12 and 19:5-6). Blessing, honor, glory, and power be unto Him that sitteth upon the throne, and unto the Lamb forever and ever" (Revelation 5:13).

In short, I will make you equal to the angels of God, and you shall be the everlasting trumpets of My praise (Revelation 7:10-12, 15). You shall be abundantly satisfied with the fatness of My house; and I will make your drink of the rivers of My pleasures (Psalm 36:8). You shall be an eternal excellency (Isaiah 60:15); and, if God can die and eternity run out, then, and not else, shall your joys expire. For you shall see Me as I am (1 John 3:12), and know Me as you are known (1 Corinthians 13:12); you shall behold My face in righteousness, and be satisfied with My likeness (Psalm 17:15). And you

shall be the vessels of My glory, whose blessed use shall be to receive the overflowings of My goodness, and to have My infinite love and glory poured out into you to the brim, running over forevermore (Romans 9:23; 2 Timothy 2:20; Revelation 22:1).

And blessed is he who has believed, for there shall be a performance of the things that have been told him (Luke 1:45). The Lord has spoken it. You shall see My face, and My name shall be written on your foreheads. You shall no longer need the sun nor the moon, for the Lord God shall give you light, and you shall reign forever and ever (Revelation 22:3–5).

And as I give Myself to you as your God, and all things with Myself, so I take you for My covenant people (Hebrews 8:10; Isaiah 43:1). And you shall be Mine in the day when I make up My jewels; and I will spare you as a man spares his own son who serves him (Malachi 3:17). The Lord shall declare, "Surely they are My children" (Psalm 87:6).

I do not only require you to be Mine, if you would have Me to be for you, but I promise to *make* you Mine (Leviticus 20:26; Ezekiel 36:28), and to work in you the conditions which I require of you. I will circumcise your hearts to love Me (Deuteronomy 30:6). I will take the heart of stone out of you (Ezekiel 36:26), and My laws I will write within you (Jeremiah 31:33).

Yet you must know that I will be sought for all these things (Ezekiel 36:37). And if ever you expect to partake of these mercies, I charge you to lie at the pool, wait for My Spirit, and be diligent in the use of the means (Proverbs 2:3–5 and 8:34; Luke 11:13).

I am content to abate the rigor of the old terms (Romans 4:6). I shall not insist upon satisfaction (Luke

7:42). I have received a ransom, and only expect your acceptance (Revelation 22:17; 1 Timothy 2:6). I shall not insist upon perfection (1 John 1:8–9). Walk before Me and be upright, and sincerity shall carry the crown (Proverbs 11:20; Genesis 17:1; Psalm 97:11). Yea, both the faith and obedience that I require of you are My own gifts (Ephesians 2:8).

I require you to accept My Son by believing; but I will give you a hand to take Him (Philippians 1:29; John 6:65), and to submit to and obey Him. But I must and will guide your hand to write after Him, and cause you to walk in My statutes (Ezekiel 36:27). I will take you by the arms, and teach you to go (Hosea 11:3–4). I will order your steps (Psalm 37:23, 31). Yea, those things I will accept from you as the conditions of life which, viewed in the strictness of My justice, would deserve eternal death (Ephesians 3:8; 1 Thessalonians 3:10; Hebrews 5:5, 9; Ecclesiastes 7:20). Grace! Grace!

## The Voice of the Redeemed

Amen, hallelujah! Be it to Thy servants according to Thy Word. But who are we, and what is our Father's house that Thou hast brought us here? And now, O Lord God, what shall Thy servants say unto Thee? For we are silenced with wonder and must sit down in astonishment; for we cannot utter the least tittle of Thy praises. What does the height of this strange love mean? And why is this unto us, that the Lord of heaven and earth should condescend to enter into covenant with His dust, and take into His bosom the viperous brook, that has so often spit their venom in His face?

We are not worthy to be as the handmaids, to wash the feet of the servants of our Lord. How much less worthy are we to be Thy sons and heirs, and to be made partakers of all those blessed liberties and privileges which Thou hast settled upon us? But, for Thy goodness' sake, and according to Thine own heart, Thou hast done all these great things. Even so, Father, because it seemed good in Thy sight.

Wherefore Thou art great, O God, for there is none like Thee, neither is there any God besides Thee. And what nation on earth is like Thy people, whom God went to redeem for a people to Himself, and to make Him a name, and to do for them great and terrible things? For Thou hast confirmed them to Thyself to be a people unto Thee forever, and Thou, Lord, have become their God (2 Samuel 7:18) to the end.

Wonder, O heavens, and be moved, O earth, at this great thing (Revelation 21:4)! For, behold, the tabernacle of God is with men, and He will dwell with them; and they shall be His people, and God Himself shall be with them, and shall be their God. Be astonished and ravished with wonder, for the infinite breach is made up. The offender is received; God and man are reconciled; a covenant of peace is entered; and heaven and earth are agreed upon the terms, and have struck their hands and sealed the indentures. Oh, happy conclusion! Oh, blessed conjunction! Shall the stars dwell with the dust, or the wide, distant poles be brought to mutual embraces?

But here the distance of the terms is infinitely greater. Rejoice, O angels! Shout, O seraphim! Oh, all you friends of the Bridegroom, prepare a wedding song; be ready with the marriage song. Lo, here is the

wonder of wonders: Jehovah has betrothed Himself forever to His hopeless captives, owns the marriage before all the world, and has become one with us and we with Him. He has bequeathed to us the precious things of heaven above, and the precious things of the earth beneath, with the fullness thereof, and has kept nothing back from us.

And now, O Lord, Thou art that God, and Thy words are true. Thou hast promised this goodness unto Thy servants, and hath left us nothing to ask at Thy hands but what Thou hast already freely granted. All we ask is this: the Word which Thou hast spoken concerning Thy servants, establish it forever; do as Thou hast said, and let Thy name be magnified forever, saying, "The Lord of Hosts, He is the God of Israel." Amen, and hallelujah.